Beryl Cook

Cruising

Beryl Cook
Cruising

Foreword by Dawn French

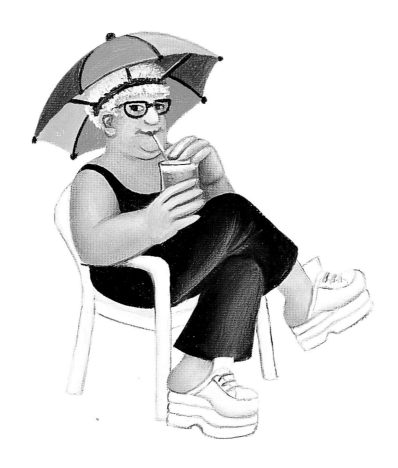

CASSELLPAPERBACKS

Copyright © Beryl Cook 2000

All rights reserved

The right of Beryl Cook to be identified as the author
of this work has been asserted by her in accordance with
the Copyright, Designs and Patents Act, 1988.

First published in Great Britain in 2000 by
Victor Gollancz.
An imprint of Orion Books Ltd
Orion House, 5 Upper St Martin's Lane,
London WC2H 9EA

This paperback edition first published in 2002 by
Cassell Paperbacks, Cassell & Co
Wellington House, 125 Strand,
London, WC2R 0BB

Distributed in the United States of America by
Sterling Publishing Co., Inc.
387 Park Avenue South,
New York, NY 10016-8810

A CIP catalogue record for this book is available
from the British Library

ISBN 1-84188-207-0

Printed in Italy by Printers Trento S.r.l
Bound by L.E.G.O., Vicenza

Foreword

Hooray, another Beryl Cook book (not another Beryl cookbook, you understand, but actually, not a bad idea).

The thing I love most about Beryl Cook's paintings is the irrepressible optimism and joy in them. Her delight is our delight. They cheer me up. No. I mean seriously, they actually change my mood. What a fantastically powerful and tangible talent she has. She is a sort of visual Prozac. Her massive popularity is no surprise, really, because in a way, we actually need her. We need to be delighted like this.

How is it that she's so great? How is it that four generations of my family love her so much? I've been looking through this fab new book and wondering about it. Perhaps it's because she is not only a kind of cheeky friend who shows us a mirror of our own familiar and flawed behaviour with a benevolent twinkle in her eye, but also a voyeur whose eavesdropping is quite deliciously embarrassing if you recognise yourself or your loved ones in her work.

I met Beryl recently and I was very glad to have had that opportunity because so much of her own personality and attitude is contained in her work. When in her company you feel that misbehaviour is imminent and I must admit that I did get a bit over-giggly in anticipation. Beryl is the real deal, she appears to have no pretensions whatsoever, no arty angst. She's the sort of person you know you want to go out with for the evening. She's friendly and warm but she's also voraciously curious, on the lookout for anything unusual or saucy. I don't think much escapes her attention and I'm sure that's why, when you look at the pictures, you just know that real care has been taken. I especially love it when she paints certain items of clothing or shoes that she fancies with such loving care. I notice in this book that a particularly stunning pair of high, stacked, backless white trainers feature a couple of times (in the self portrait at the front of the book and in *Jazz in the Summer*). I know for a fact she first spied these shoes on my friend Claudia, who was visiting her from London, and she has obviously taken a liking to them! So, she's a sort of thief, really, stealing from our lives, but in a way we don't mind because she treats her contraband with such celebratory panache.

I don't think I had particularly noticed these shoes until Beryl, through her paintings, demanded that I did. Her unique talent persuades us to focus on the things that matter to her, whether it's shoes and make-up or pain and pleasure. Surely this is evidence of an extraordinary artist.

It's so easy for snooty critics (the art world seems to be overcrowded with them) to overlook or dismiss her work, because a) she is spectacularly prolific, so they aren't convinced she is suffering enough to produce anything sublime and b) her work is so utterly enjoyable, so universally loved, therefore ... how can that be right??!

This particular collection has the feel of a happy and confident hand at the

wheel. Beryl the seasoned traveller is in evidence. She enjoys spectating other people's holidays just as much as she is obviously enjoying her own.

Beryl the Bristol resident is here, too (it would be so great if she henceforth referred to herself as 'Bristol's Beryl'), turning her watchful eye on her new surroundings. Thank goodness, we also still have some moments from the familiar surroundings of the Dolphin, with Billy and his customers.

I have identified so much with Beryl Cook's work in the past that I have sort of decided that she is part of my family – the artistic part I never had. I fantasise that I am her favourite niece, and she loves me so much that she chronicles my children, my pets, my pub crawls, my hen night, my wedding, and my funeral. I can claim to have some real things in common with her, though. She lived in Reading (certified as the most average city in the country), as do I. She lived in Plymouth, as did I (where I kissed exactly the sailors she once depicted). She drank at the Dolphin, as did I. Oh, and she's 'a bloody 'ansum maid …'

In the end I may have to admit that, like many admirers of her work, I feel a supremely personal connection with it. That doesn't really make her my actual auntie, though, does it, if we're honest? Shame.

However, it does make her one of my all-time favourite people, someone we should truly cherish. I'm all for instigating 'Beryl Cook Day' where we get to have a day off, get a gang of mates together, dress up in stacked shoes, fishnets, tight skirts and green make-up, with our best hip-length fake-fur coats on, and go out to have one Malibu too many, flash at boys, and have a good cry on the way home in the cab, proclaiming our love for each other and anyone who's passing.

Bugger it, I'm going to do it anyway … coming?

DAWN FRENCH

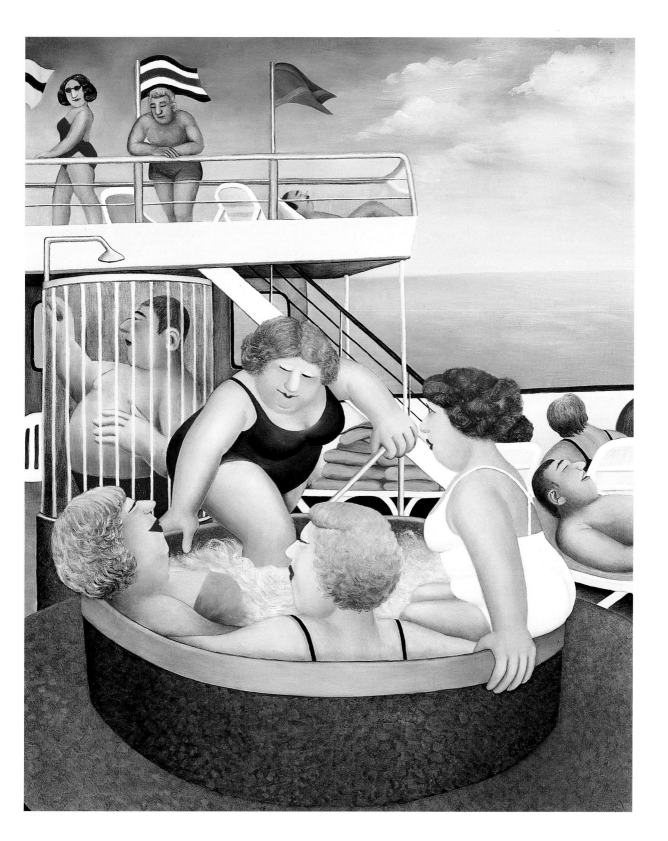

CRUISING 1

Here we are at sea on a lovely sunny day. There is an extremely large man taking a shower – I was not at all sure he'd manage to fit into the stall, but he just made it. This was the first time we had been on a cruise and I thoroughly enjoyed it all, especially stopping every day at a different port. Mostly people sunbathed on this deck, but just in front of where I sat was the jacuzzi, which was very popular.

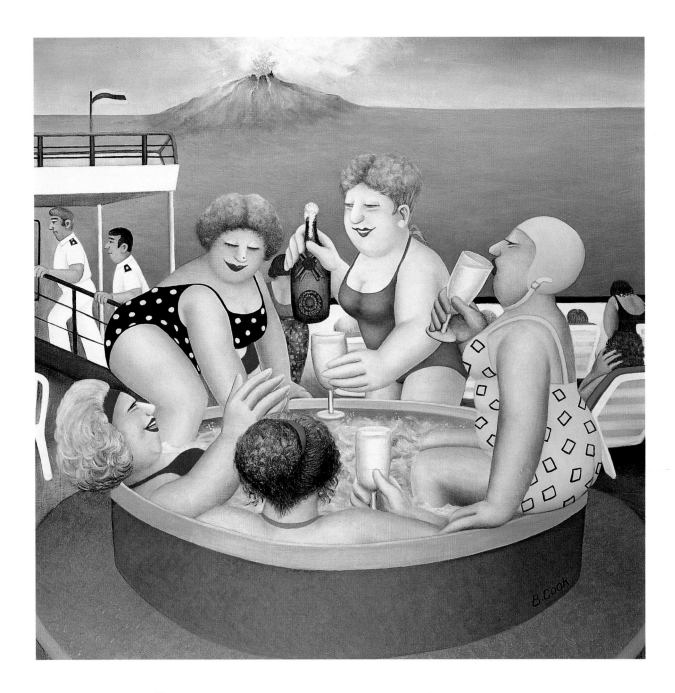

CRUISING 2

Here is another picture of this cruise, with a slightly different background. One of the things I had hoped to see was a volcano in full eruption, cascades of lava and fire everywhere as shown in old prints of Naples, but I had to be satisfied with Vesuvius looking peaceful and quiet in the sunshine. So I gave my version a large fiery top, to show it was a volcano. Two of the ship's officers, glamorous in their uniforms, stroll past in the background, and the ladies share a nice bottle of champagne this time.

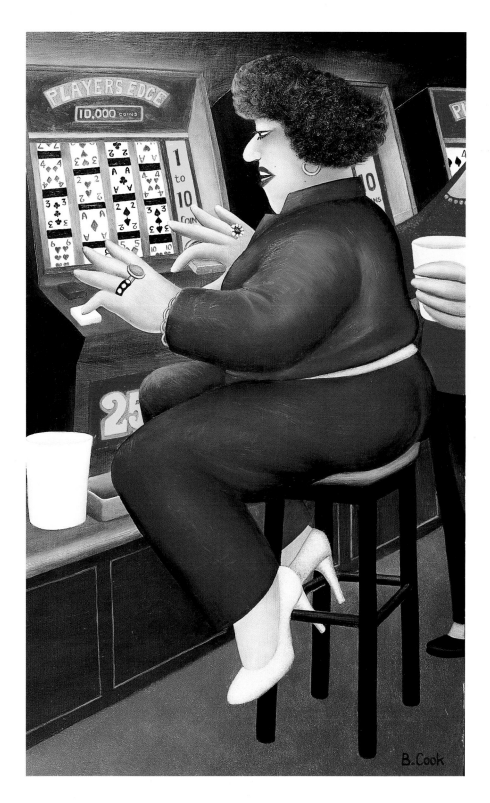

NOW NUDGE

'Now Nudge' is the button her finger presses, and the cup waits for the fortune that will come gushing from the machine. There is always a gaming room on the cruise ships and I like to spend an hour or so playing the slot machines. Some like a lot more than this, and will guard their chosen machine with their very lives. Sometimes they play two together; I saw a woman in America doing just this and smoking a cigar at the same time. This lady was quite dedicated and did not leave her 'Player's Edge' for the whole time I was there.

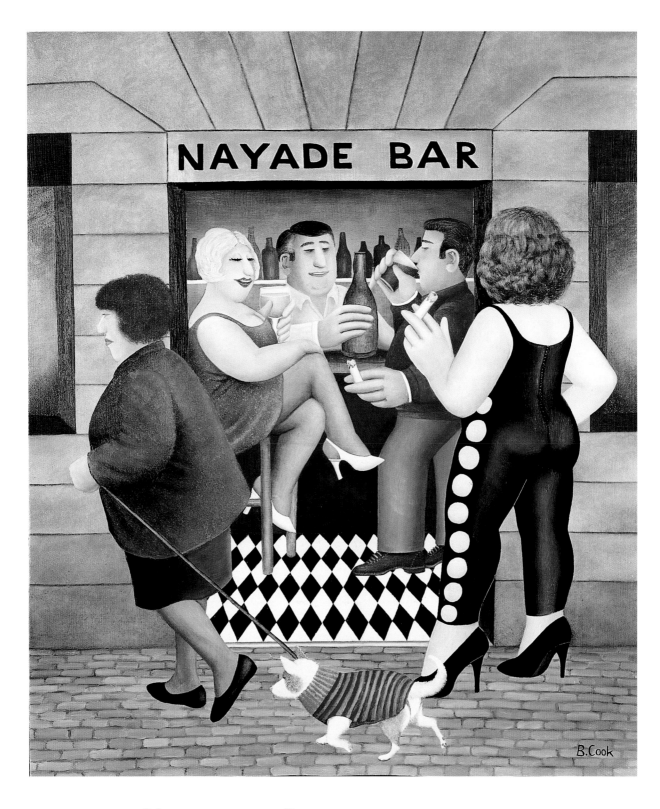

Miguel in the Ramblas

This is Miguel, dressed so smartly in his hand-knitted blue- and red-striped jumper. He was quite old and trotting along behind his mistress, and she called him by name as he paused by a lamp-post. I chose this little bar as a background for him because I was so taken by the girl, in her amazing outfit, standing outside. I'm puzzled as to how she got it on and off – it can't have been easy (or warm either). There are lots of little bars like this in the side streets off the Ramblas in Barcelona, a wonderful place to visit.

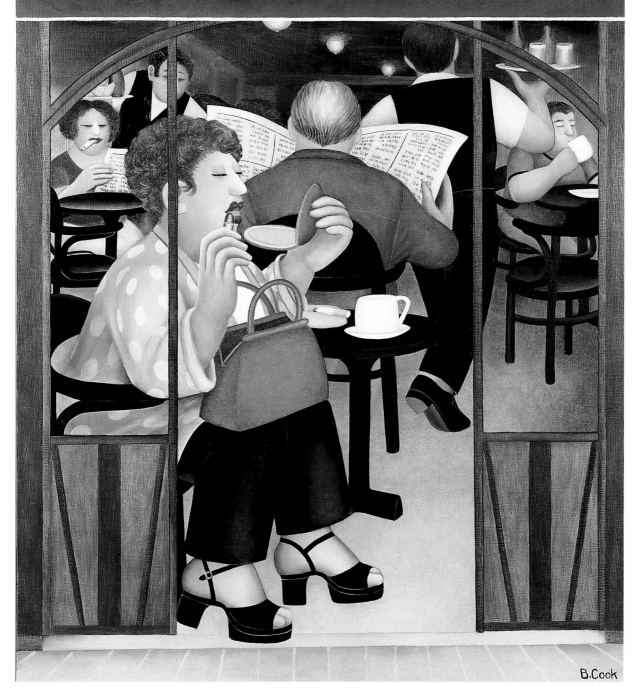

Café de l'Opéra

Our hotel in the Ramblas was close to this café, where we stopped every morning
for coffee or – in my case – hot thick chocolate with *churros* (doughnut sticks) for
dunking. As I sat enjoying this healthy snack in there one day I noticed my neighbour,
contentedly smoking and reading the newspaper. Eventually she finished up her coffee
and prepared to leave, finally applying a glistening new layer of lipstick. And here she
is, sitting by the door now so I could paint both her and the café from the outside.

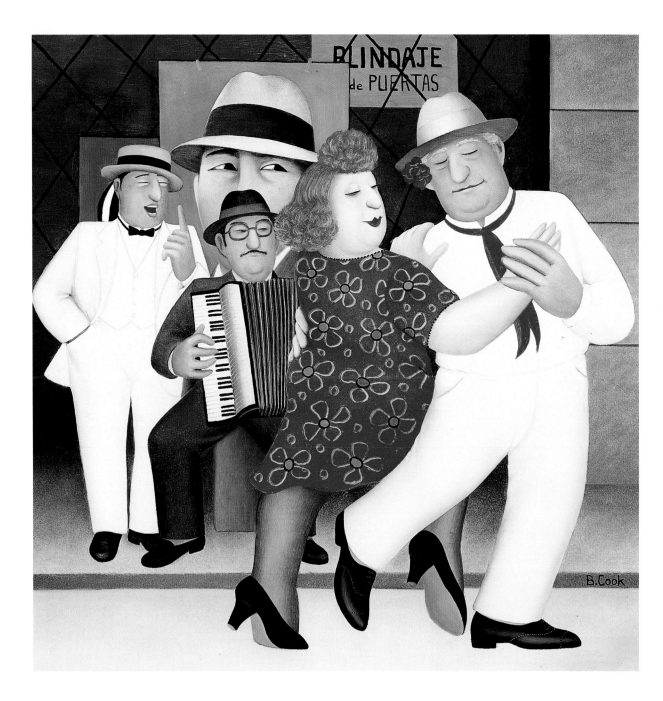

Tango Busking

Ah, happy days in Buenos Aires. We were in a district called San Telmo on a Sunday morning, where an antiques market was held each week. The streets were full of pavement cafés, and in the lovely weather a variety of tango experts performed for our entertainment. We found this little group in a side street just as we were leaving, so we stopped to have a last look.

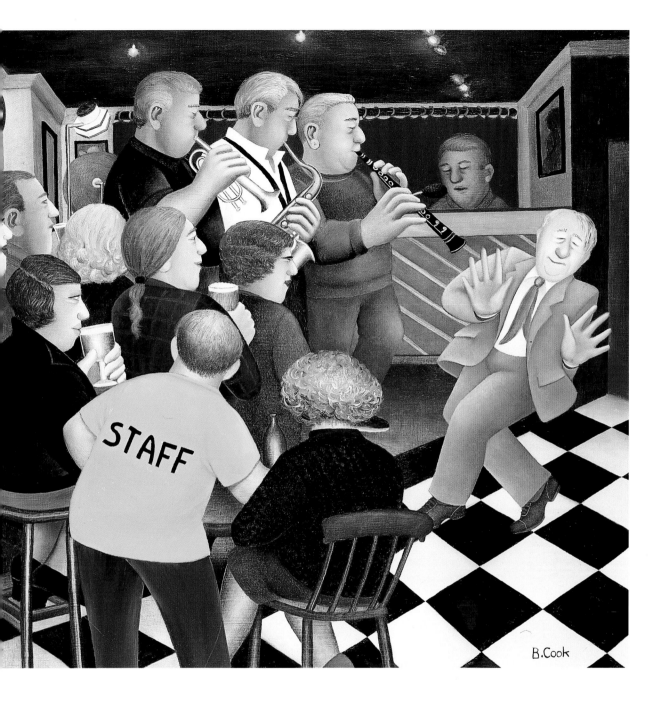

JAZZ IN THE WINTER

Our granddaughter and her family live in Bristol, and we moved here ourselves early
in 1998. I knew how much I'd enjoy living in this exciting city, and I loved it from the
start. Nowadays Friday nights are generally spent in this pub, the Duke, where jazz
is played most days of the week. Here I've painted the little old drunken man I saw
dancing there one night. After he'd lurched into the bandstand once or twice one of the
musicians calmly stepped down, took him by the arm and guided the dancing figure
out of the door, never a beat missed. Another night the door opened and a boy came
in, danced all the way to the gents, and soon afterwards danced all the way back
again. Best of all, he had bright red hair, my favourite.

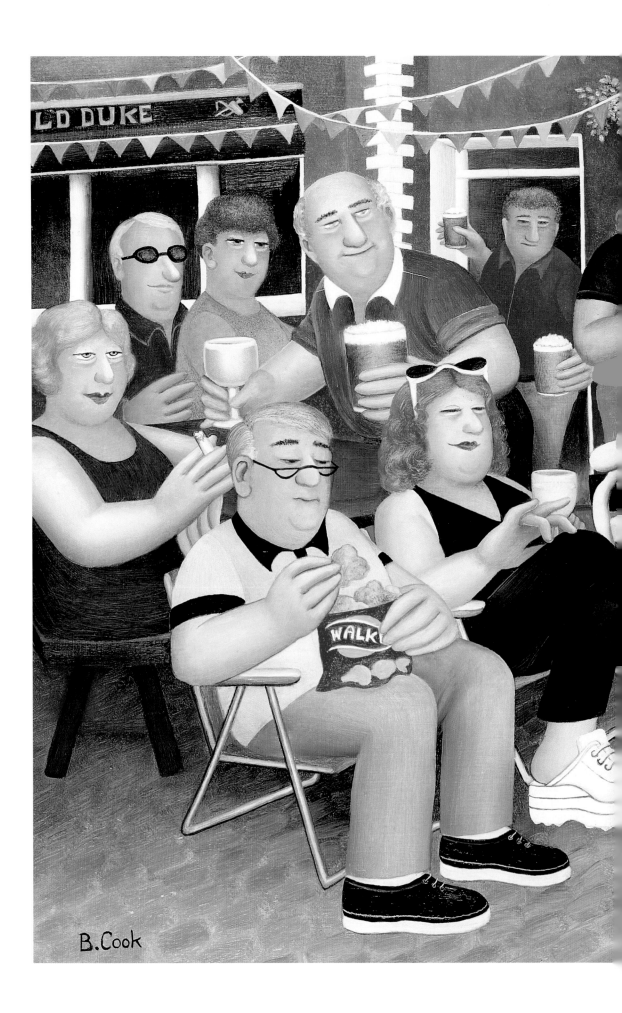

Jazz in the Summer

Summer Sundays often mean jazz in the streets or parks, and it's wonderful sitting outside the pub in the sunshine near the water, listening to the music. The bands play on a sort of stage and on this particular day it was so busy we had to sit behind it, facing the audience. As you can see they are all enjoying themselves, fingers tapping, drinks and crisps circulating.

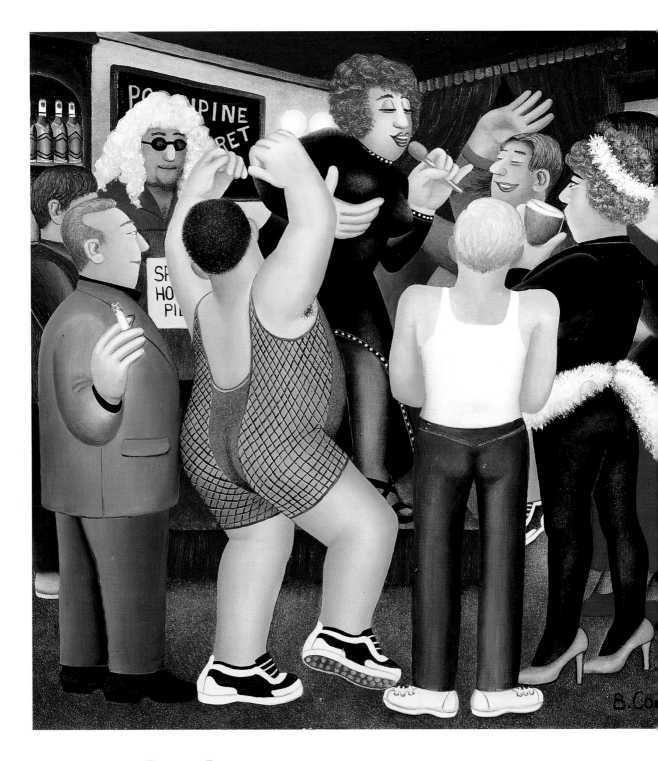

Party Boys

This party was in full swing as we entered the Porcupine one night. Most people were dressed to the nines and one was mostly undressed, in fishnet combinations. What fun the singer was – some were dancing to the music and others gathered round to applaud. I had seen the man in the blond wig on another occasion and he made us laugh so much I decided he should put in an appearance here as well.

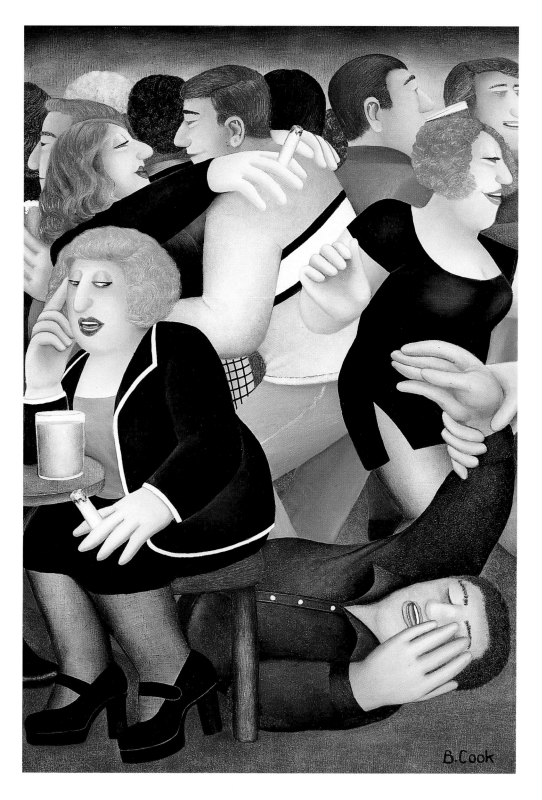

Friday Night

This is a busy picture, rather like our Friday nights. The body on the floor is unusual, though – he'd flown through the air and landed at our feet without any warning. There had been slightly raised voices earlier, but nothing more. A large bouncer bustled over and dragged him off by one arm, and we all got back to our various activities. We saw him later going off with a bruised face. What he'd been doing to earn it we shall never know.

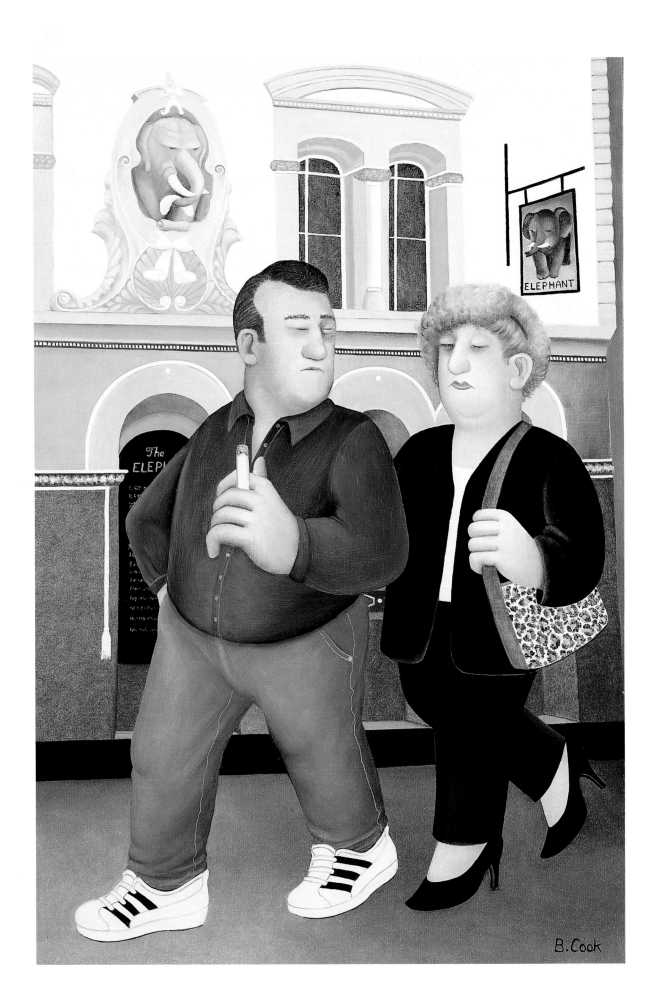

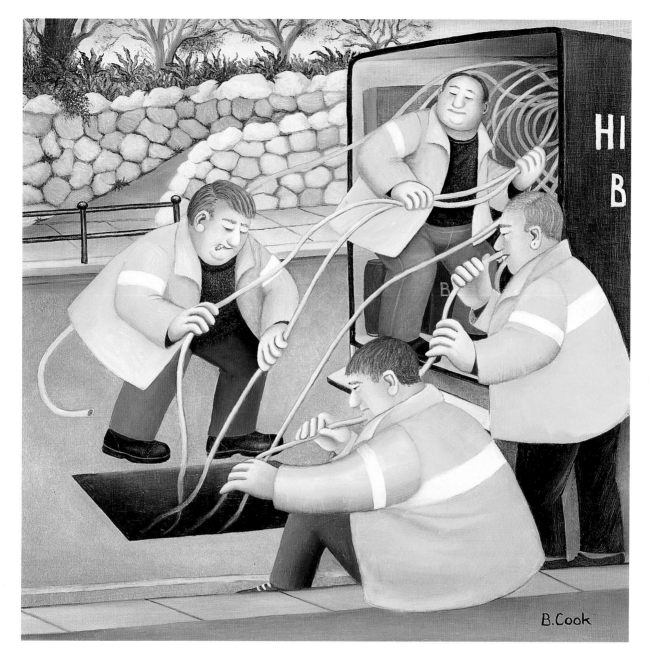

B.Cook

Dyno-Rod

Every day we walk into Clifton Village to get the newspaper, and one morning whilst crossing the road I came across this little scene. Intrigued by all the pipes, I asked one of the men if he was Dyno-Rod. No, he's dynamite, another swiftly answered. There and then the picture formed in my mind. I always call it Dyno-Rod, but John tells me it is more likely to be telephone wires they are dealing with.

The Elephant

There are some beautiful buildings in Bristol, new ones as well as old, and they are a source of great pleasure to me when we are out and about. The elephant emerging from the wall on this one is a favourite of mine, and I decided to use the building as a background for a couple I'd seen in a shopping centre. As they passed we realised they both had black eyes, and were looking rather grim about it. As I was drawing this picture the figures got larger and larger and the building smaller and smaller, but I still kept a good view of the elephant. He looks disapproving, doesn't he?

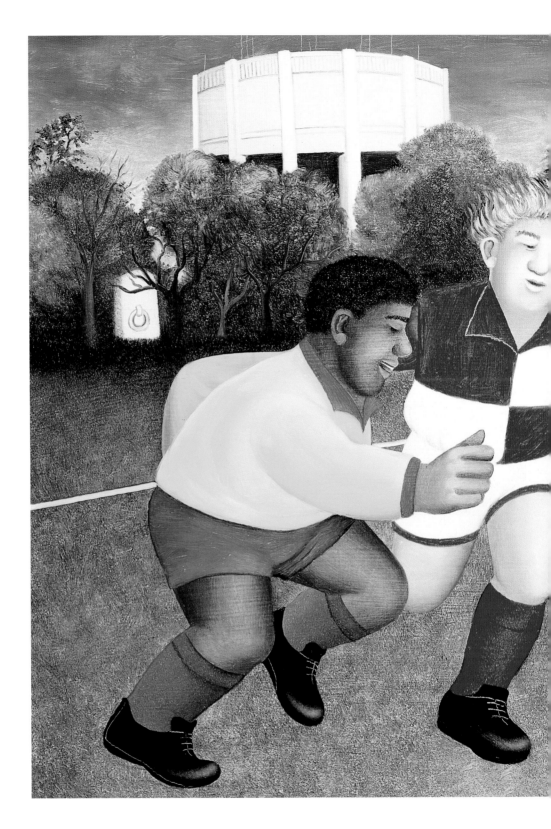

FOOTBALLERS

As the weather improves I like to take my paintbrushes out for some healthy open air exercise. We are lucky to live near the Downs and go there every afternoon with our little dog. There is every possible activity going on: in high summer it's picnics, kite flying, sunbathing and barbecues. In the football season all the kits appear and hearty games are played to loud shouts of encouragement. Here are some of the players, their hair flying in the wind as they race towards the ball for a powerful kick.

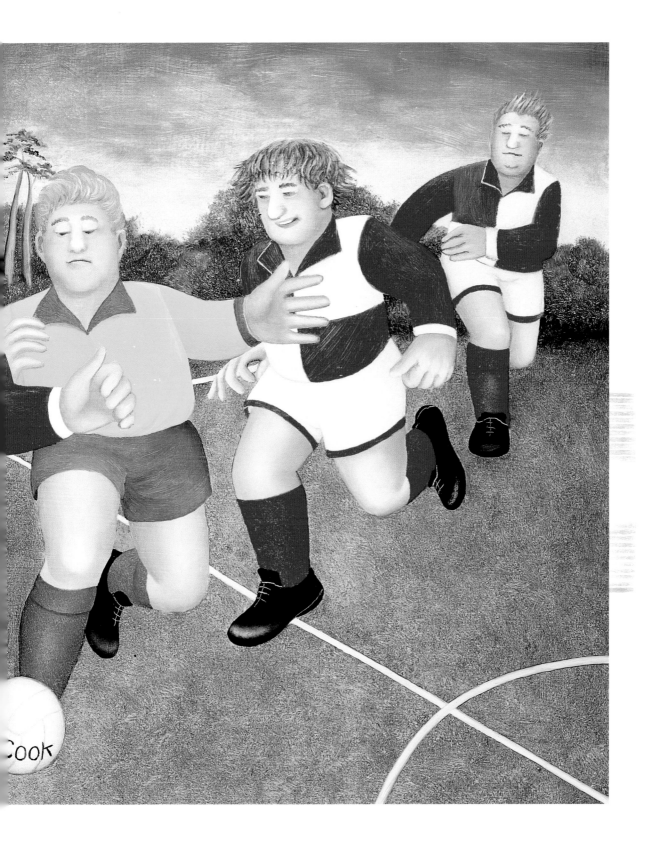

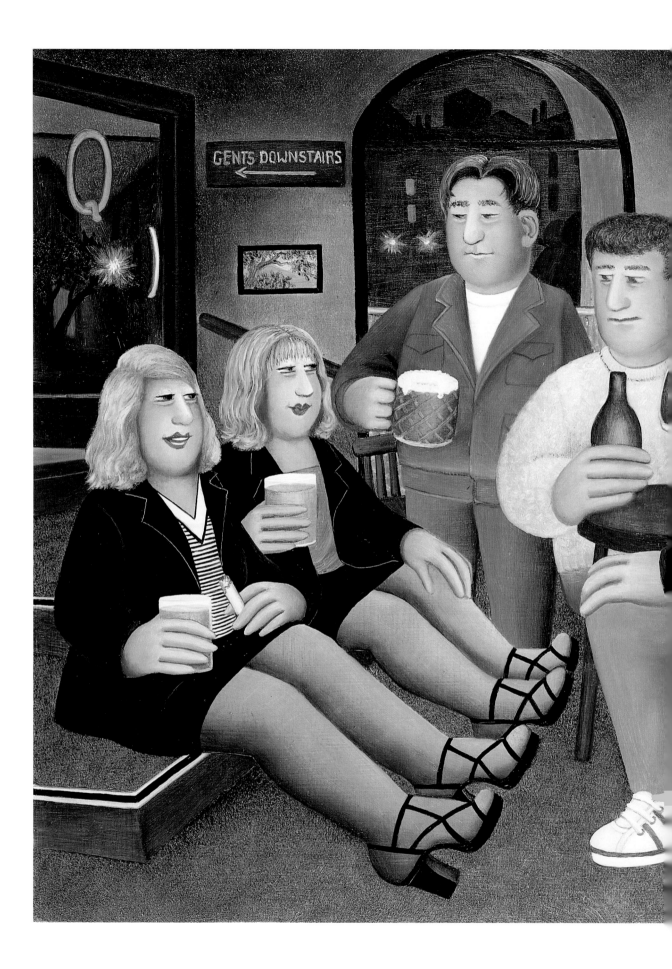

B.Cook

STRAPPY SHOES

This is the Quadrant in Clifton Village, where
we often call in for a drink at the weekend on
our way to the city centre. On this particular
night some of the many students who live
round us were in here having a drink. There
weren't enough chairs, so two of the girls sat
on a nearby step, legs outstretched in front,
and it was then I noticed their identical
strappy shoes, perfectly placed for a drawing.
The man standing has a very popular hairstyle
– a centre parting with hair springing out on
either side.

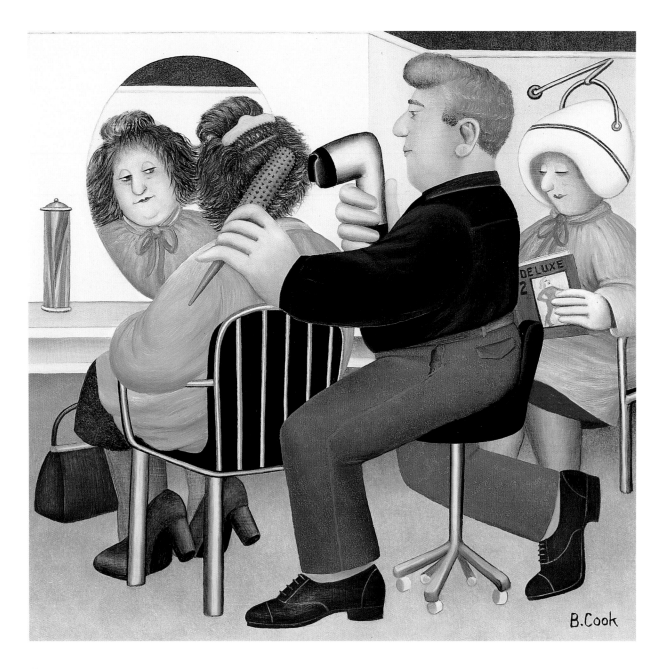

SALON PHILIP

This is a small area of the salon where I have my hair done. Over the years I've painted all the salons I've been with, as the hairdressing itself fascinates me. In this case, though, it was Mr Philip's chair that caught my eye. As he attended to the hair on each side in turn he swivelled the chair round rapidly with his feet, gliding swiftly over the floor. How easy, I thought, and much better than standing all the time. By the way, I have never actually seen this bird's-nest hairstyle in his salon; it's my attempt at untidy hair in need of attention.

SHOPPING MALL

Here are some more strappy shoes, very popular at the moment, and a lot of happy shoppers. They are using the escalators whilst beneath them thousands more on various levels are milling about between the shops. The man holding the parcel doesn't look well, does he? I'm not surprised – John said he felt ill several times when he was there. I think these shopping malls are for us ladies.

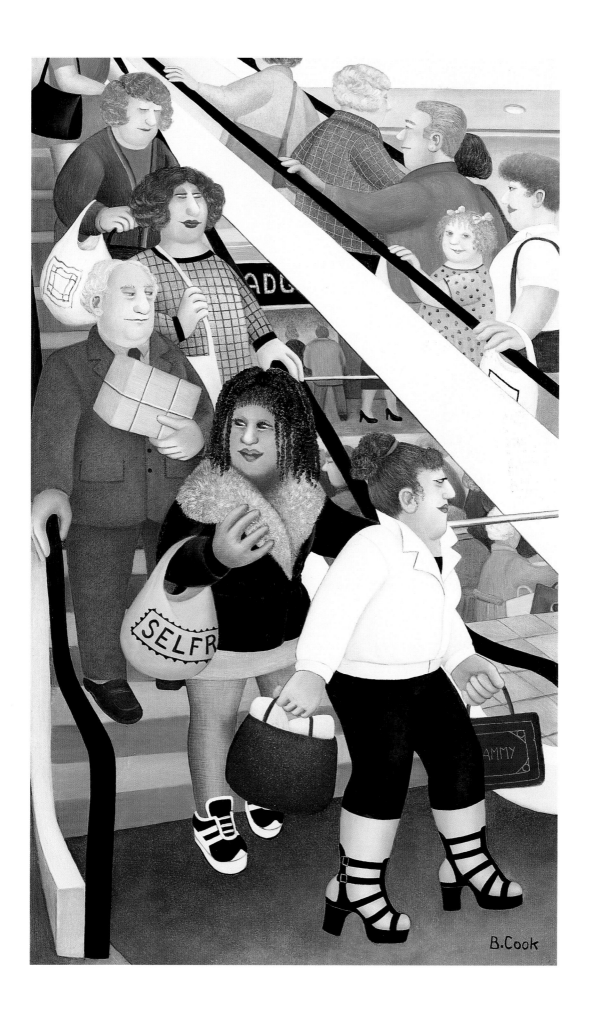

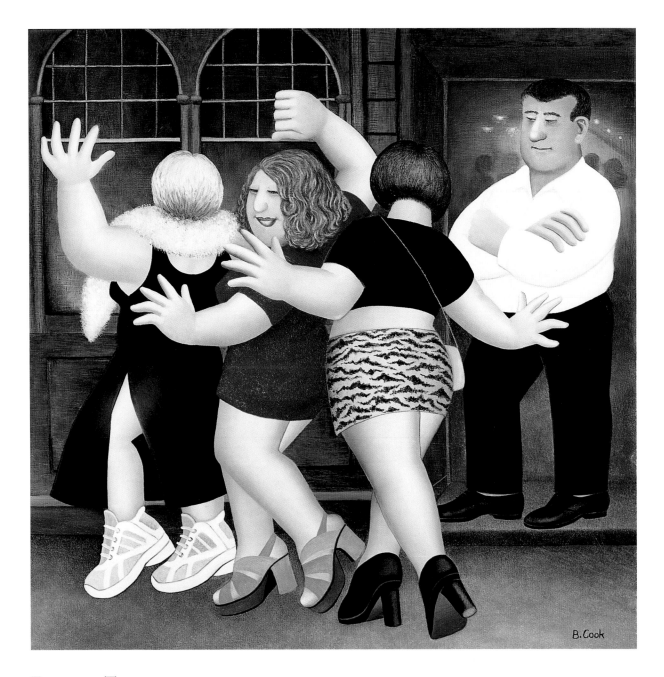

END OF TERM

Leaving the city centre one evening we were followed by a group of girls excitedly talking and laughing together. As they passed they called out 'End of term, end of term!' and waved. Here they are, watched by a bouncer in the doorway of the Porcupine, one of our regular ports of call.

MORNING RUN

These are some of the joggers we see in the mornings when out with the dog. This exercise isn't nearly so popular as it used to be a few years ago, and considering the hills there are in Bristol I'm surprised that anyone here takes it up at all. Some spring along lightly, but to others it's a real effort, and one man grunts in anguish with every leap he takes. I liked the piece of path they're on because of its curves, and photographed it to use as a background. Normally there would only be one runner on the path, but I like to get as many people as possible into my paintings.

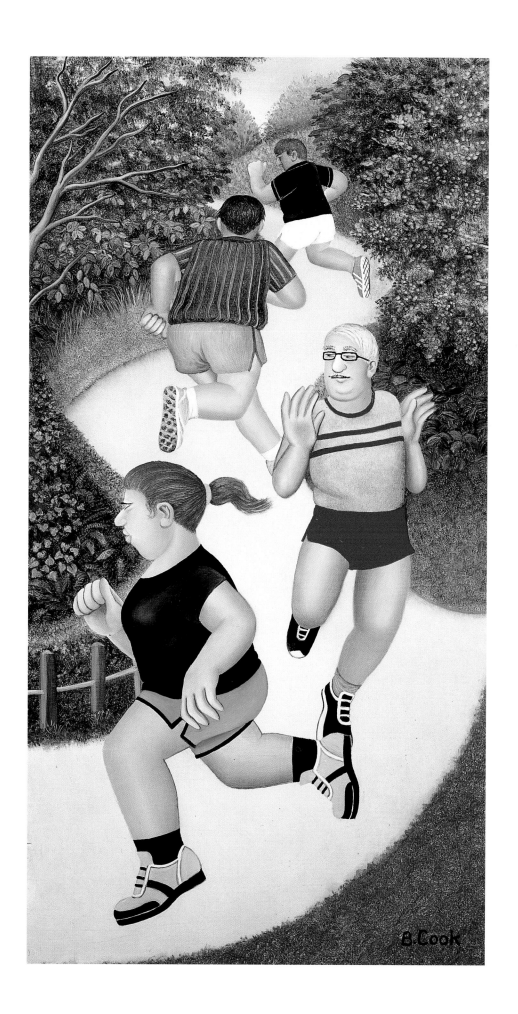

STRIPPERGRAM

This group of men was standing together in front of our table in the Dolphin one evening when they were joined by a fat little lady in a blue coat. Singling out the birthday boy she suddenly peeled off the coat, revealing this slightly grubby corset and black lace knickers. Open-mouthed, we watched as he was made to kneel and have his head massaged by her now-naked bosom. I'm not sure what he thought about his birthday present: I was hastily sketching the incident inside my handbag.

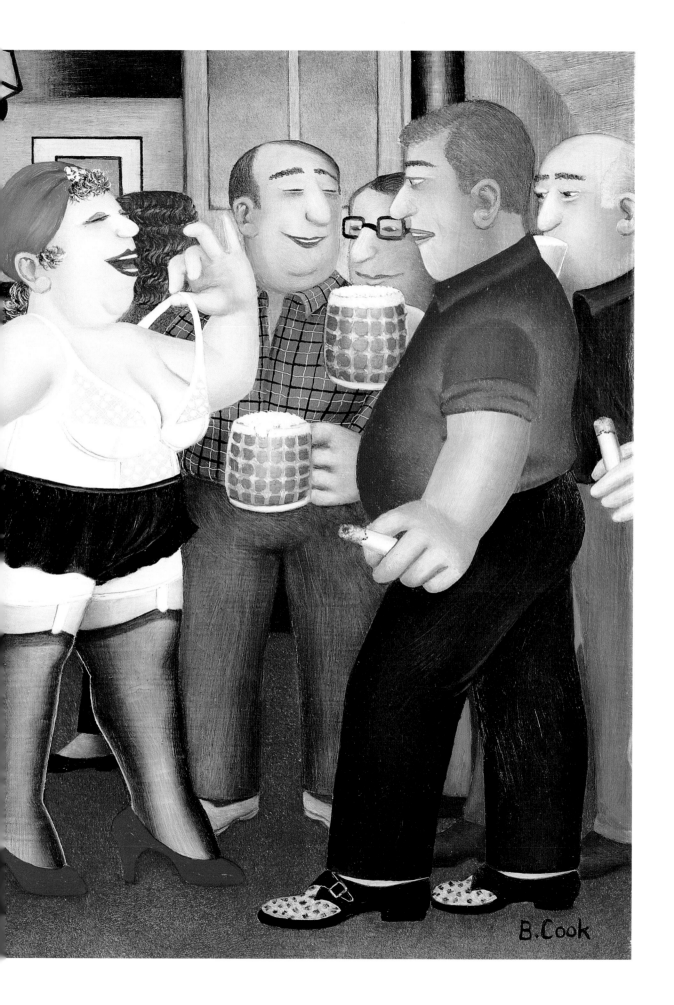

B.Cook

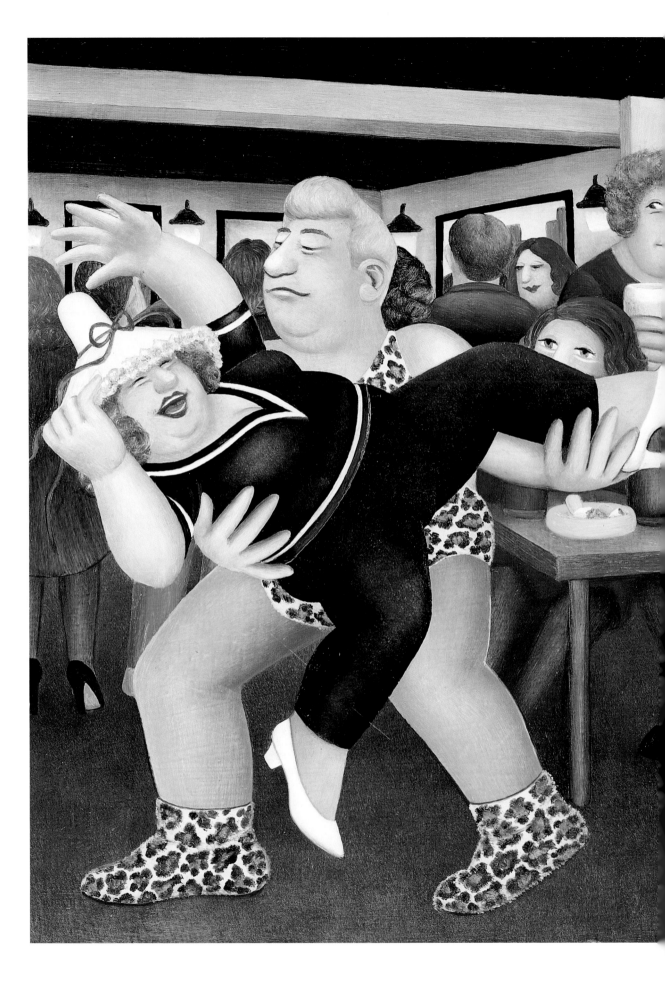

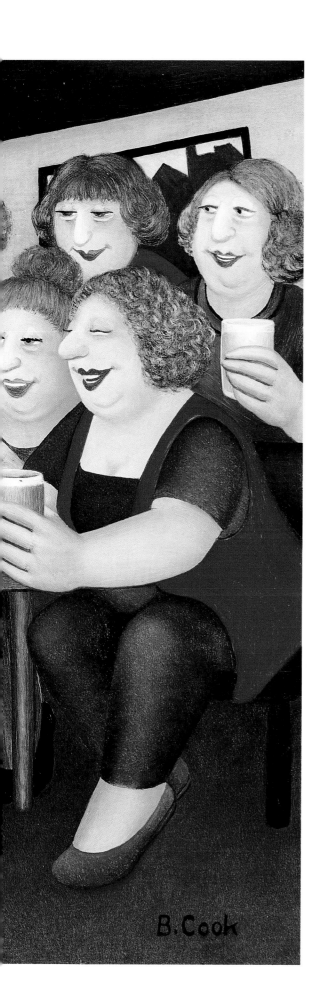

B.Cook

TARZANOGRAM 1

This is a friend having a hen party. Her mother arranged for Tarzan to appear during the proceedings, but as she is rather nicely rounded I don't think Tarzan managed to throw her about as much as he'd planned. She is wearing her special hen party hat. I always enjoy these rituals and like to see the groups of girls going through the streets singing and laughing. They are often so loud we know they're on their way before we see them.

Tarzanogram 2

When Sue told me that she'd had two special hats for her party I decided to paint another picture. She also told me that Tarzan had tried to get her up on his shoulder but had been quite unable to manage it. I felt I needed to show the supreme effort he made, so I gave him a look of anguish. I think poor Tarzan has probably retired with a hernia by now.

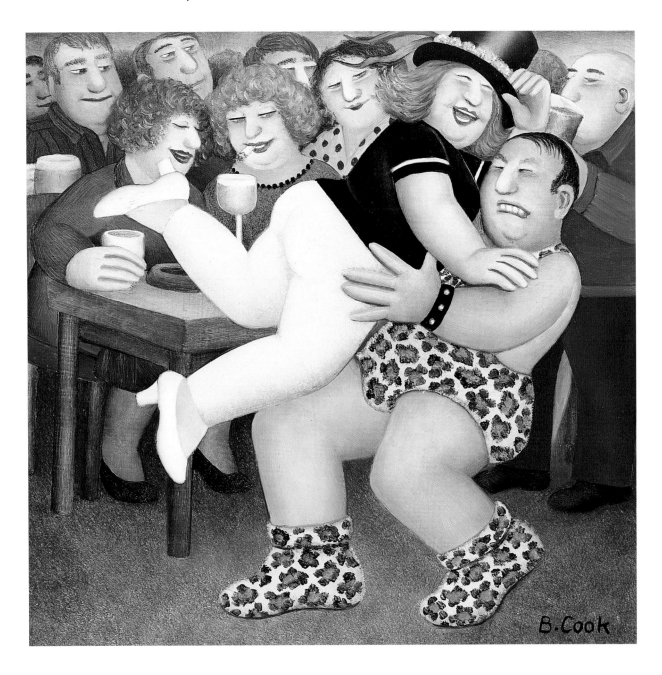

B.Cook

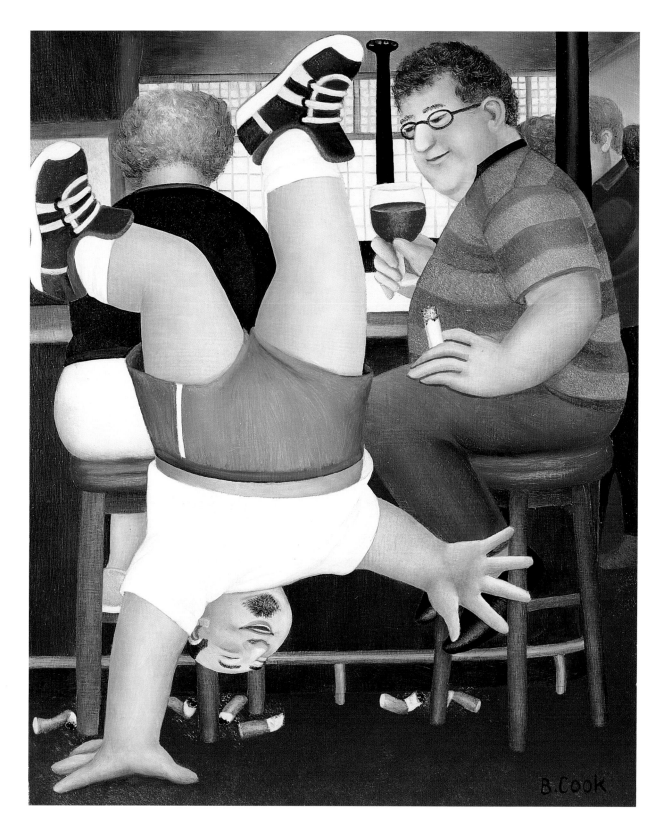

A Cartwheel for Billy

Billy was sitting near us chatting to a friend one evening in the Dolphin. Later Billy came across to talk and told us that this friend once did a series of cartwheels through the bar after they had been out together. This is only one of many unusual things to happen in this pub, and it formed an immediate picture in my mind. Quite recently I met the cartwheel man, but he didn't offer to repeat the performance for me.

ELVIRAS CAFE

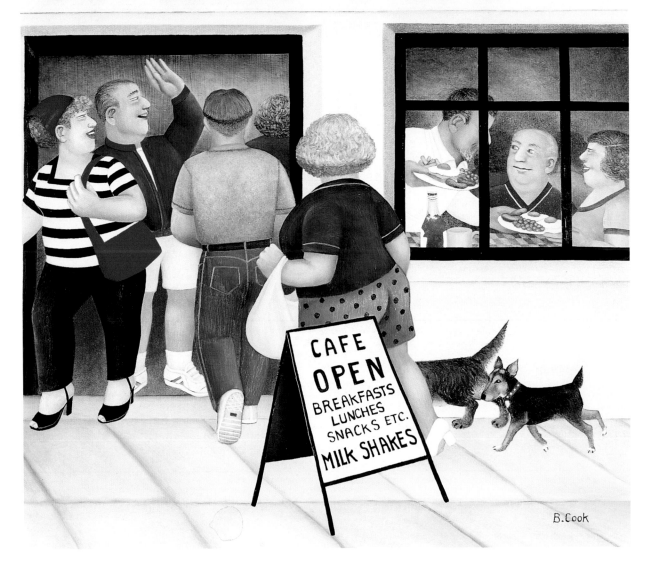

B. Cook

ELVIRA'S CAFÉ

This café belongs to our son and daughter-in-law and is very popular, although there is plenty of cheek served up with the food. After they had owned it for a year or two, and I'd painted a picture of the interior, they decided to enlarge the building, so this is a view of the outside. Dogs are very welcome in here – they always get a sausage – so Lizzie, our black terrier, hurries in to get her share. There's also a glimpse of our son through the window, serving breakfast. He's more likely, though, to be found at the back, cooking.

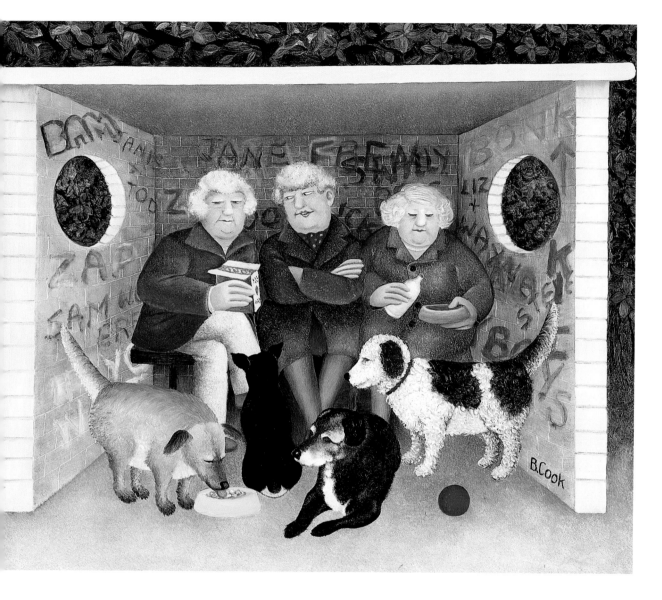

A SHORT PAUSE

We used to take Lizzie for walks through a large park, and our route took us by this
hut. It had been covered in graffiti so often that eventually no effort was made to clean
it – an invitation to meet Steve in there at 6 o'clock for something revolting always
caught my eye. Regardless of their surroundings these ladies always met there to chat
and provide titbits and drinks for their dogs at about 3 o'clock every afternoon. I've
added a back view of Lizzie to the group; she would willingly have joined them for a
biscuit. Years of graffiti on walls takes quite a long time to reproduce, I found.

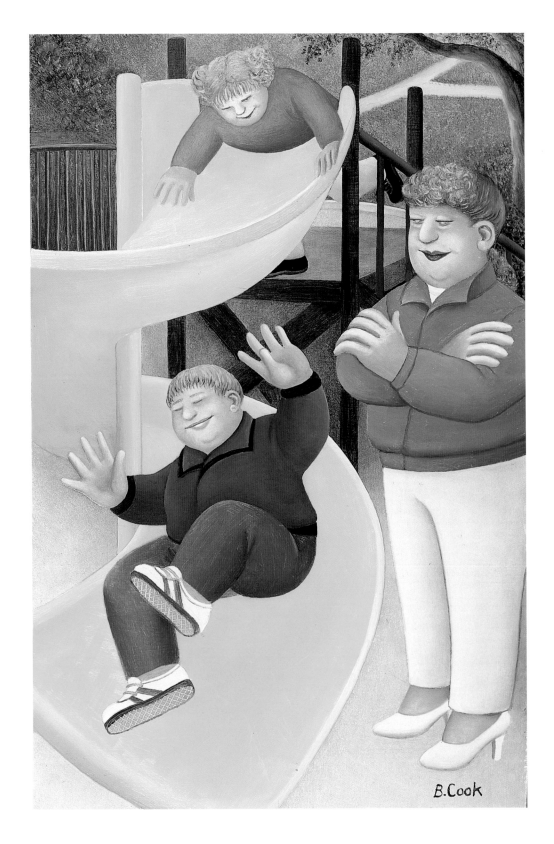

PLAYGROUND SLIDE

I love the energy and movement at playgrounds, with all the children swinging, climbing and sliding. Sometimes there's rather more shouting, hitting and fighting instead. In this case it was the yellow slide that took my fancy – this is the only one I've seen in a playground and I liked it a lot.

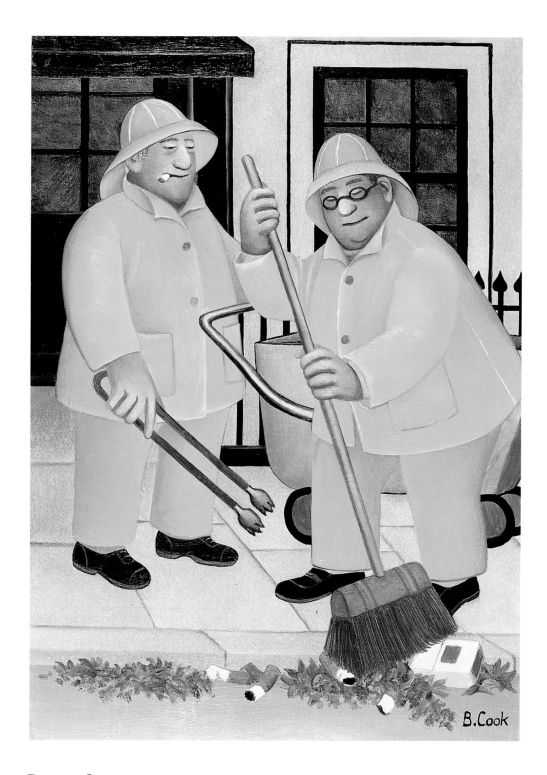

ROAD SWEEPERS

The bright yellow outfits must be the attraction for me as I've done several paintings of road sweepers and workmen. This one was painted for a charity some years ago, and I remember following these men around as they busily swept the pavements. They were wearing hats as it was raining, which I haven't managed to depict, but the gutter is rather good, isn't it?

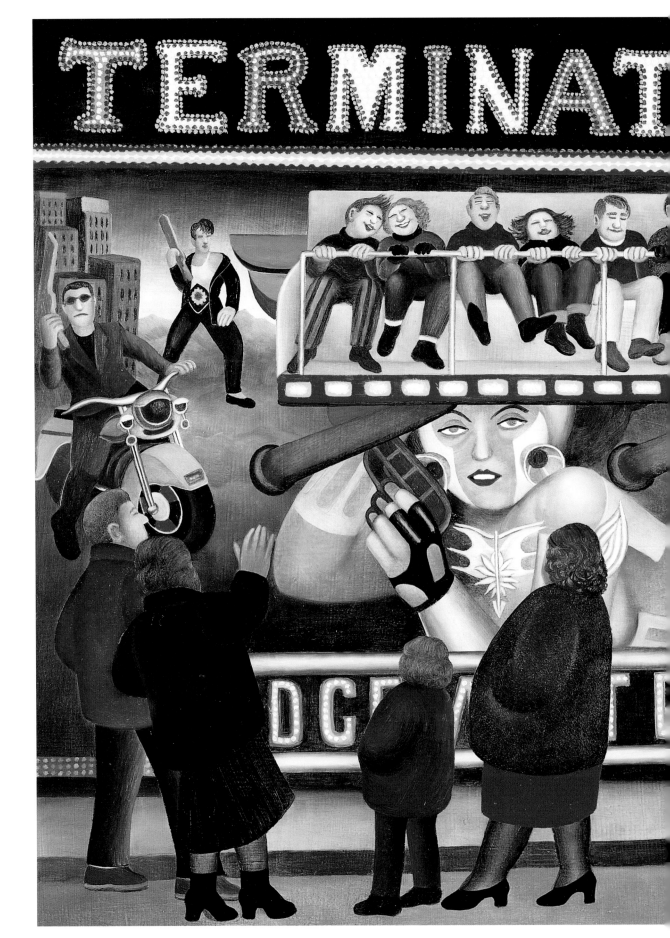

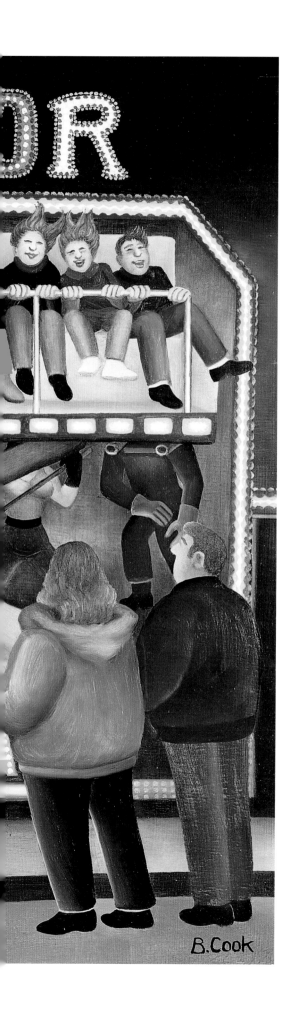

B.Cook

THE TERMINATOR

On winter nights in the city centre fairground rides are set up in various places. They are popular with the youngsters, and I liked watching this one, which caused loud screams and flying hair as the machinery arm hurled the seating up and down. I was also fascinated by the decoration, so I took a photograph. After a great deal of hard labour and much swearing this picture was produced. I think I'll stick to just looking at these things in future.

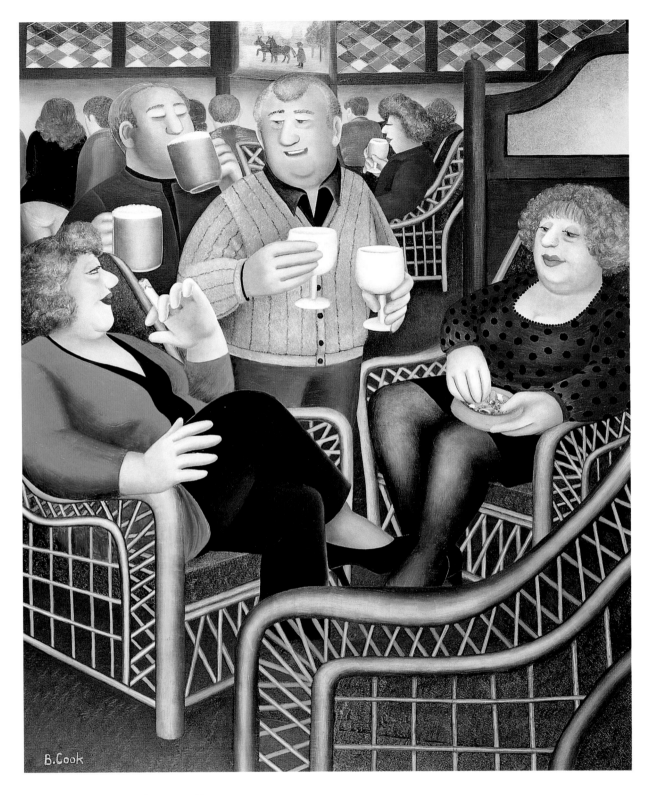

CANE CHAIRS

Aren't these chairs nice? In the time it took me to paint them I could have woven all of them by hand. But having started the painting I felt I must continue. The surprising thing was that they suddenly appeared in the front bar of this same pub. I'm not sure what impression the owners were aiming at, but I think these chairs were a mistake, for the only position once seated was to recline, after which it was not so easy to rise at regular intervals to replenish your glass. Knowing I would be painting them we made several visits, and were often the only customers enjoying these luxury objects.

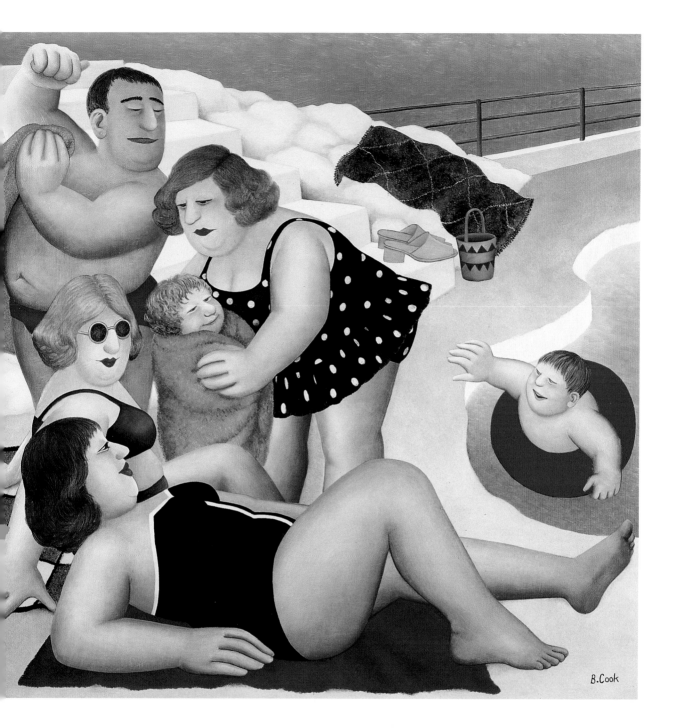

SUMMERTIME

This is a corner of an old outdoor swimming pool, no longer used and falling to pieces, which I chose as a background for this family party. I had been watching everyone enjoying themselves in the sunshine and liked to see them having picnics and swimming, so here they are, one little boy still in the water. What I haven't painted – but hope they have with them – is a huge picnic basket, full of goodies.

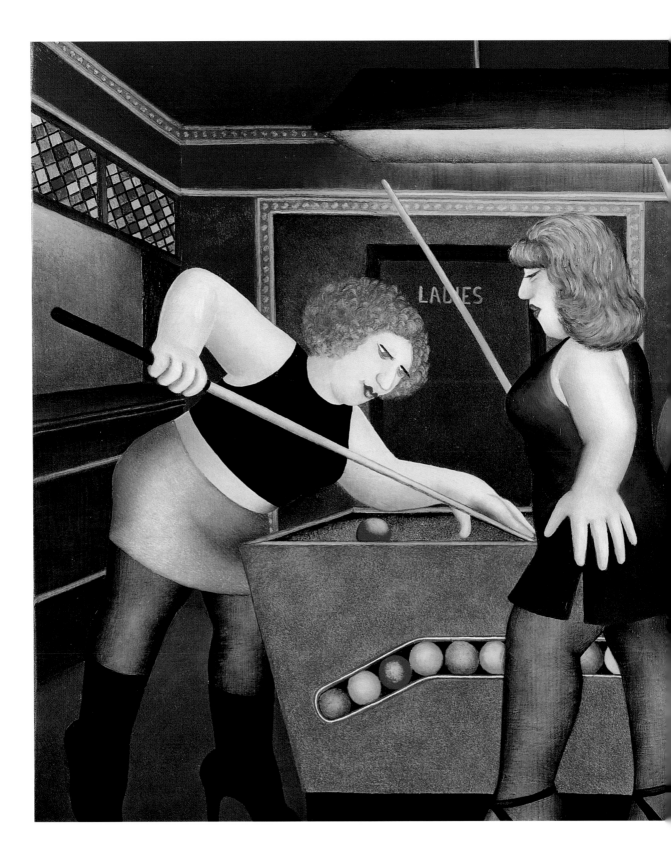

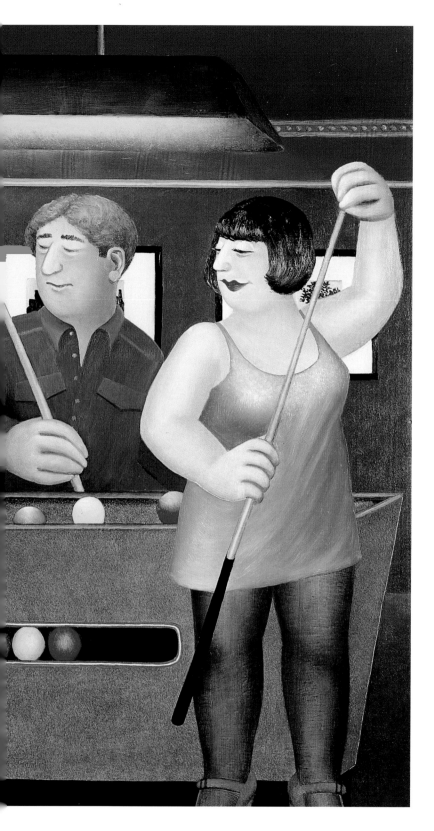

POOL TABLE

One day a pool table appeared in the back of a shabby pub we used to visit occasionally, and to my great pleasure three attractive girls, dressed to the nines, were enjoying a game with one of the locals. I'm always willing to paint a pool table because of the colours, and this time I had such a good view of it all. So here are the girls at their game, each holding a cue in an artistic manner.

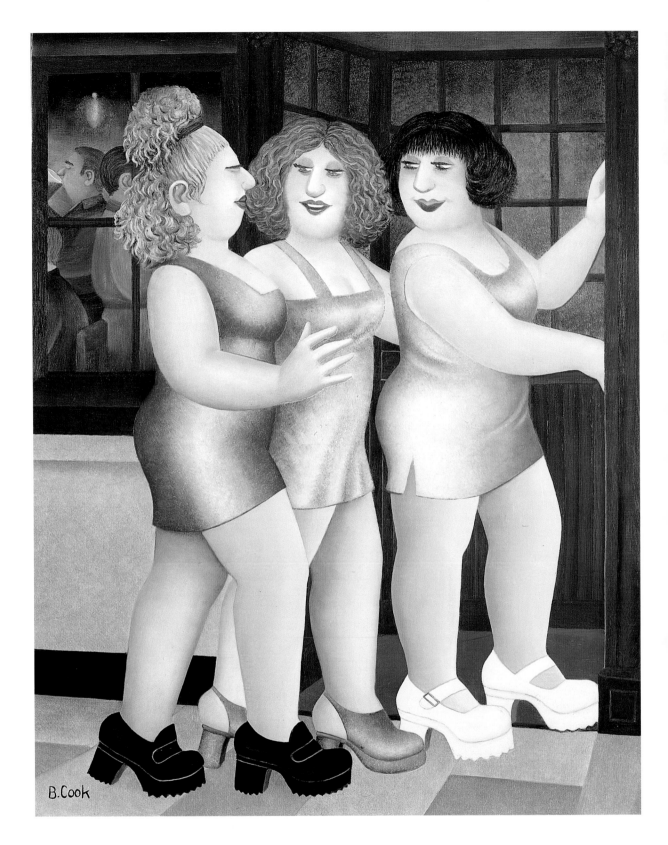

SATIN DRESSES

I like to see the girls out and about enjoying themselves in the evenings. They all start appearing, ready for fun, just as we oldies are wending our way home. These three were entering a pub door as we were leaving ours. They wore tiny little satin dresses and very large shoes, and had frizzy hair; they looked all set for a lovely evening.

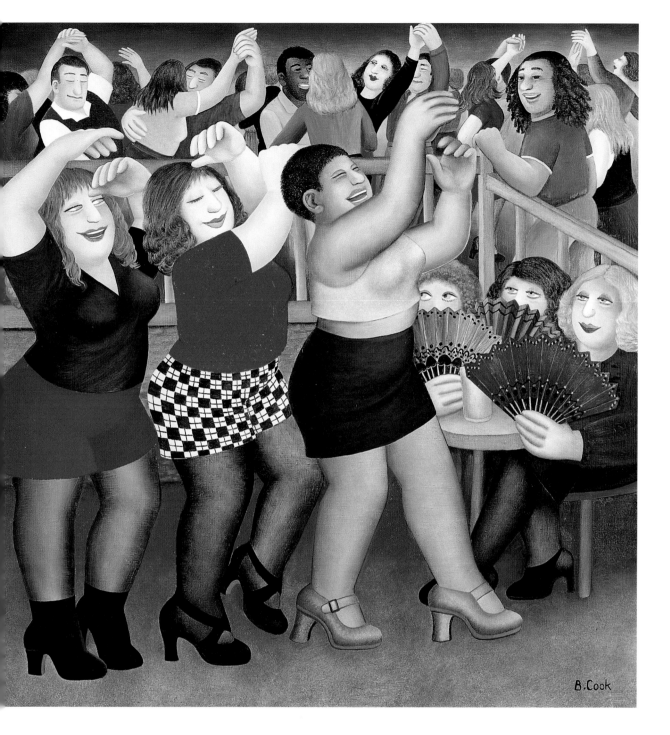

Doing the Lambada

We had been to the theatre in London and as we came out we were met by our South American nieces, who asked if we would like to go to a local salsa club. Would we! We hastened round to get a good seat, and the girls explained that earlier on everyone had had a lesson on how to do it and now they were putting it all into practice. And how they danced. John said he enjoyed it much more than the show we'd seen. The atmosphere was lovely. Some of the girls used fans to cool off after particularly energetic performances.

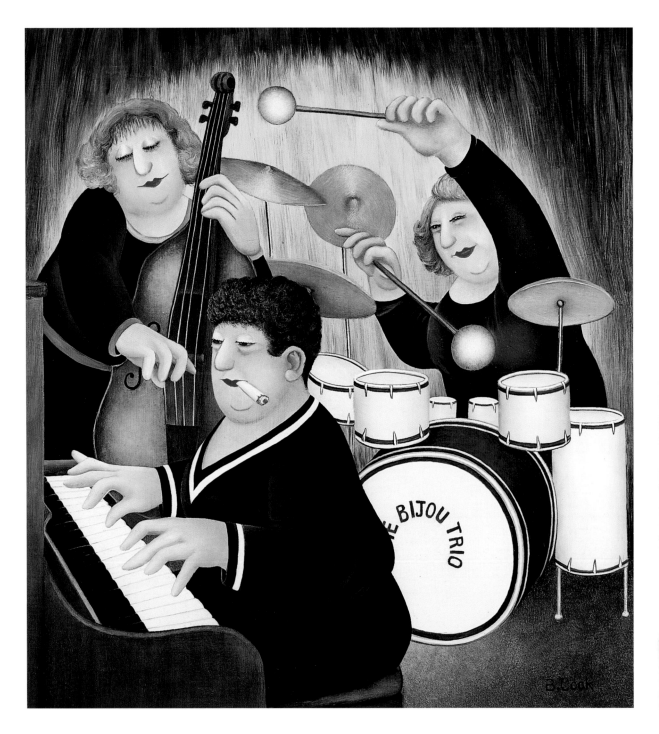

THE BIJOU TRIO

One year the Portal Gallery in London decided on a musical theme for their Christmas show, and this was my contribution – three sturdy girls and their instruments. I like painting musicians: I often paint pianists, and I'm not too bad with the double bass either, but I now see that the drummer is having to perform on a rather tiny drum kit. She doesn't let this stand in the way of an enthusiastic rendering, though.

Lingerie Shop

Gazed into by me as we passed it on our way to the Portal Gallery. I took such a fancy to the underwear I decided to paint it, and whilst discussing this with a friend, learned that portly little gentlemen often escort their lady friends into the shop to buy them something nice. I expect they need portly little gentlemen to do the purchasing as it all looked lovely but very expensive.

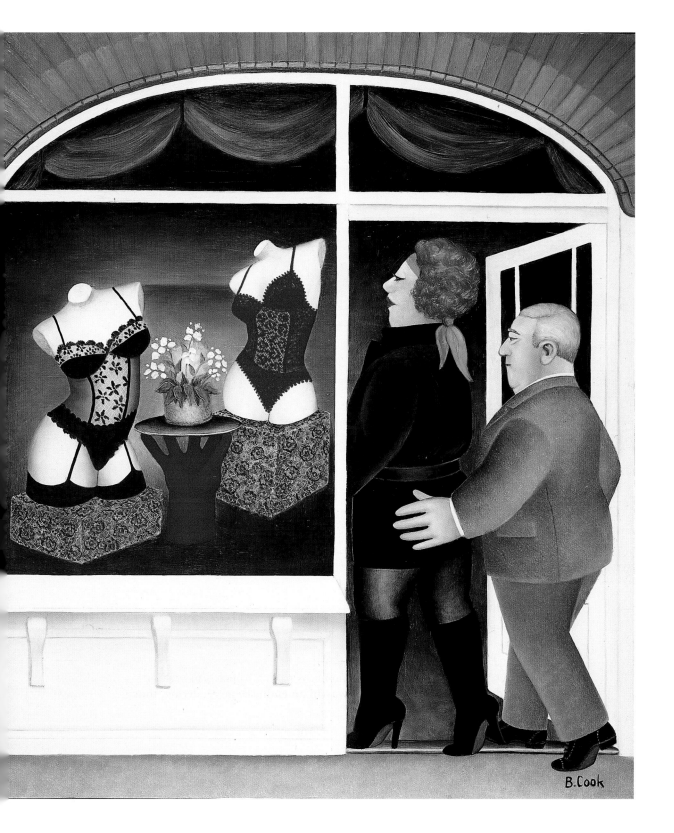

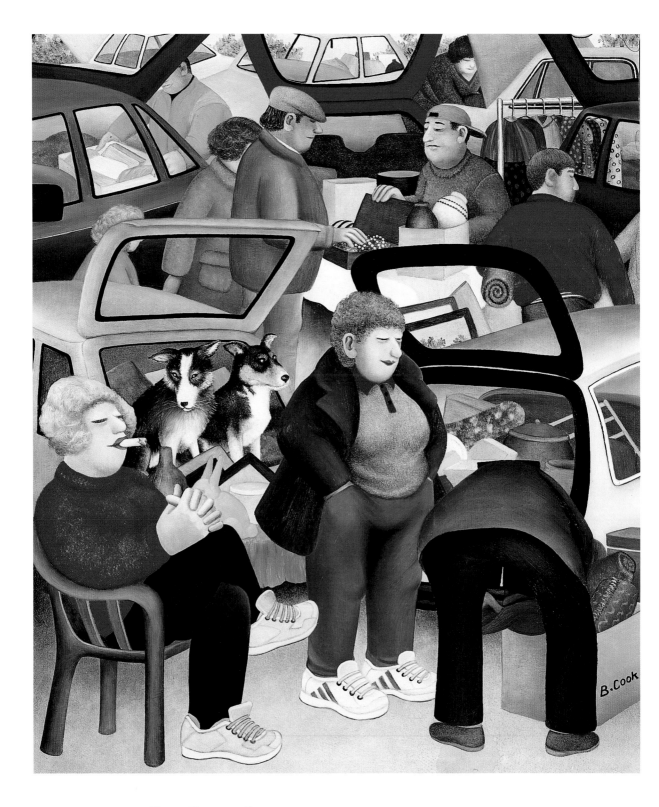

CAR BOOT SALE

I've been to several of these, but although I have bought many a little gem for 25p I have never found out later on the *Antiques Road Show* that one of them was worth thousands of pounds. This is rather a satisfactory painting for me because I succeeded in arranging five car boots in a fairly small space. I didn't have far to look for junk to be tastefully arranged in the boots, since it's all round our house, crying out to be painted. A friend obligingly removed her trainers for me to use as models for the ones worn by the lady seated in the front of the painting.

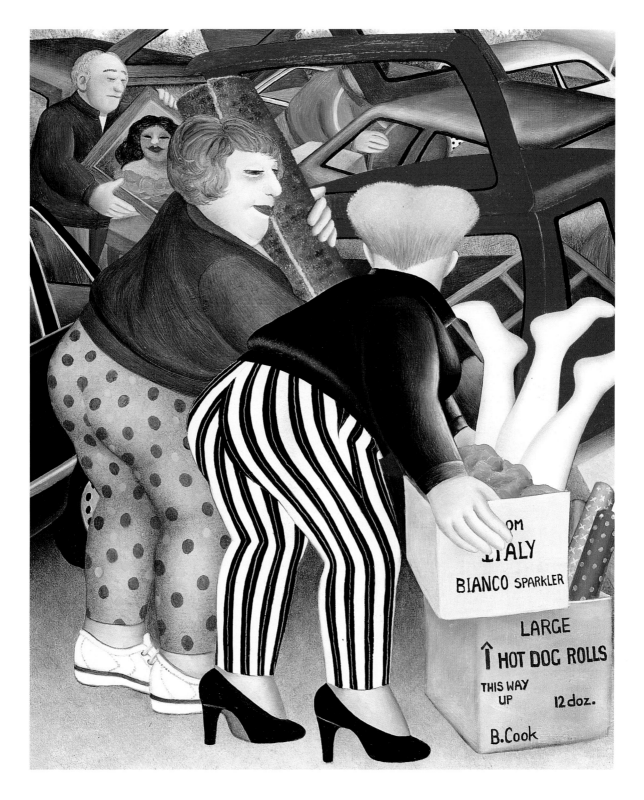

Off-Loading

After I'd finished the first car boot picture I found that I hadn't managed to include the legs. John bought twelve of these (by mistake) at an auction, and they were so popular amongst friends that I now only have three left. I like painting them and so I decided to do another car boot picture, which would also enable me to use a hairstyle I'd seen and sketched. This is the pale ginger back view, which had mesmerised me as I stood in a queue at a cash till.

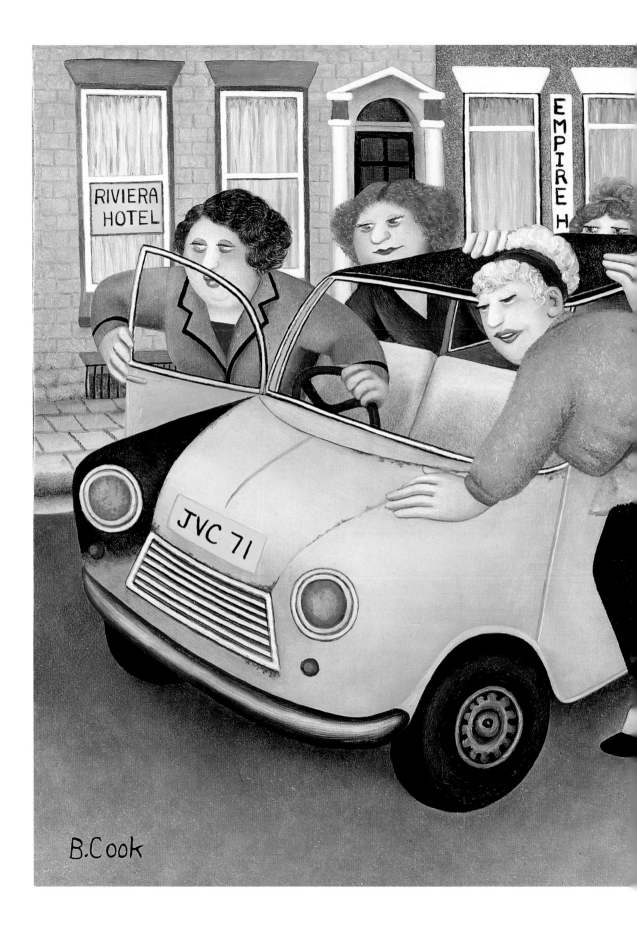

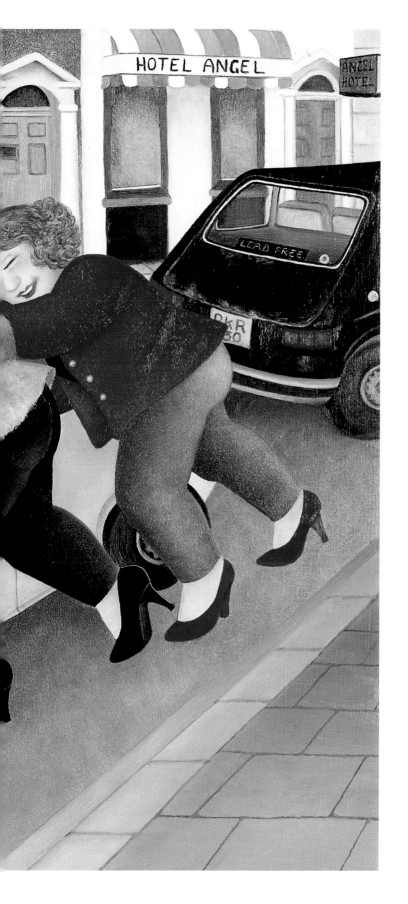

A GOOD LITTLE RUNNER

A few years ago Joe told me he had
seen from his window a number of
young men running and pushing a very
small car down the road. I was
reminded of this one day when I came
across a photo I'd taken in Liverpool
of a row of small guest houses in a
back street. To complete the picture,
the perfect motor car was regularly
parked near our house, a rusty little
banger just about to fall to pieces, and
this became the star of the painting –
pushed down the road by women
instead of men.

BRIDGE PARTY

These lucky ladies are each smoking a nice big
cigarette. Reluctantly, I had to give up this habit
a few years ago, but one troublesome day, when
I really felt I'd like one, I sat down and drew this
picture instead. In my room, kept handy for such
occasions, is an ancient ashtray with quite a
large selection of ash, old dog-ends and half-
smoked cigarettes, relics of the smoking days of
yore. These I use as models when I'm adding a
touch of realism to a gutter or pub floor.
However, these are ladies, holding cards which I
hope are suitable for bridge. Actually they are
the cards with the least number of spots, because
I grew tired of painting them in the end. Of
greater interest to me are their black dresses,
which I think would look nice for an evening
card party.

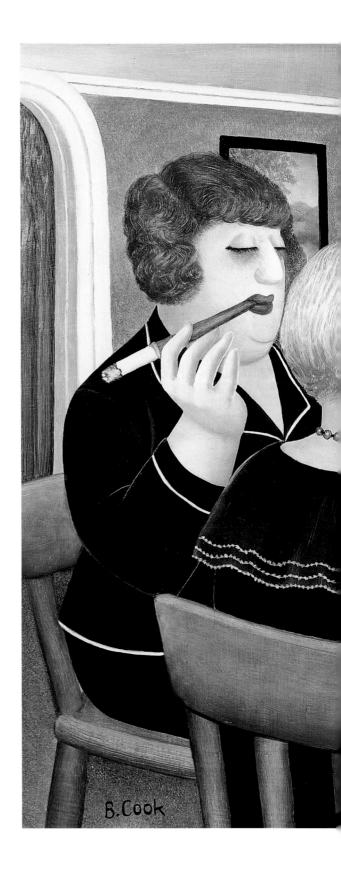

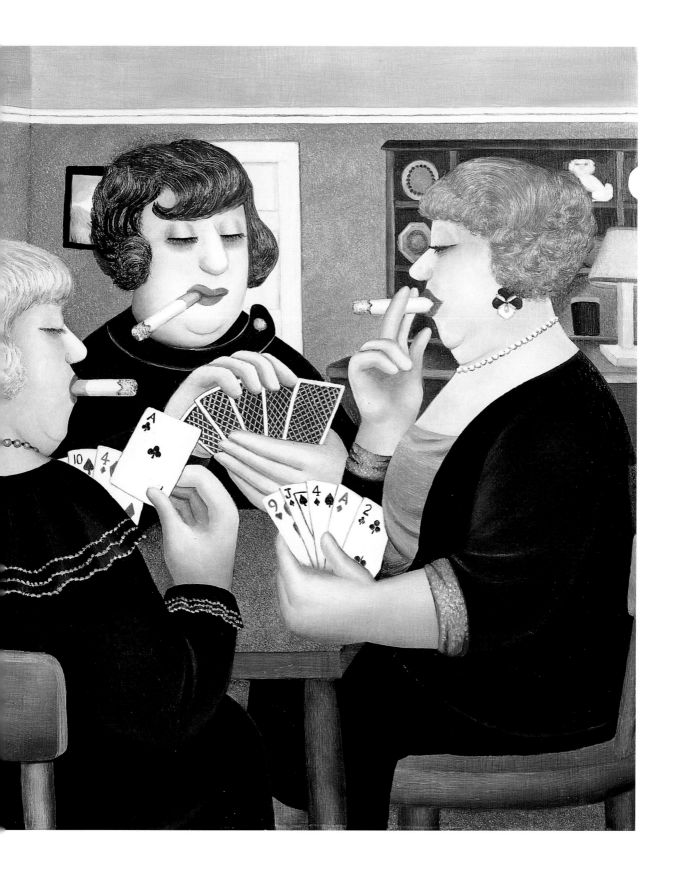

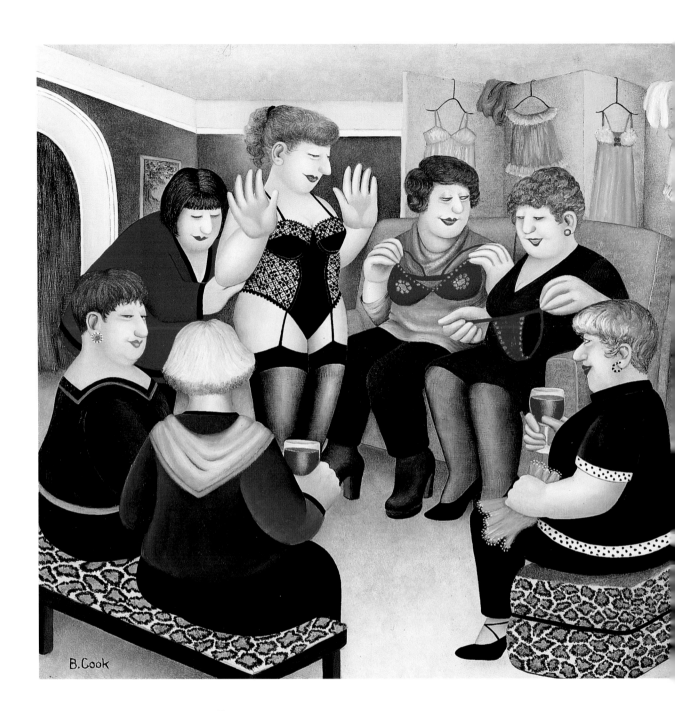

PARTY GIRLS

I haven't been to one of these parties although I've been invited. I've heard quite a lot about them and how much they are enjoyed. Are the undies hanging on the screen perhaps a trifle small compared with the size of the ladies? I expect it's just perspective.

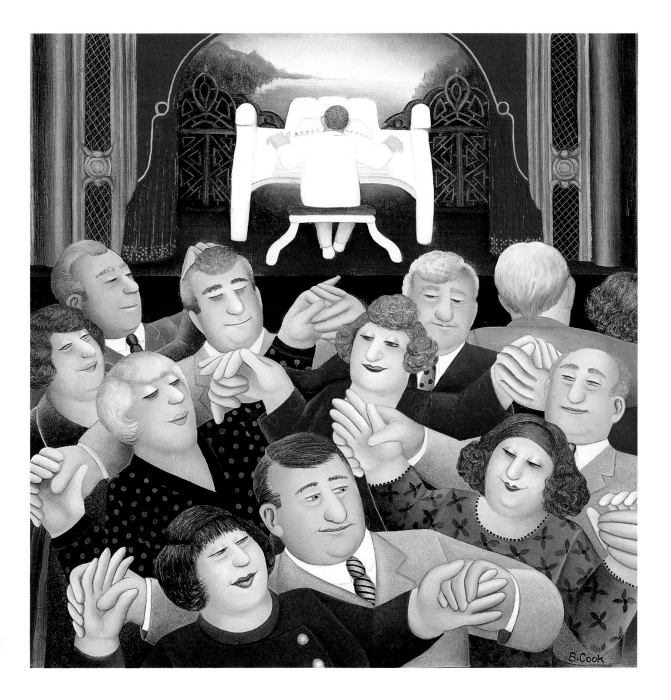

DOING THE SAUNTER

I particularly liked this magnificent ballroom in Blackpool, and the organist dressed in white. The saunter was my favourite dance when we went there a few years ago, the ladies guided by the men from behind. The organist occasionally looked over his shoulder as he played to make sure the dancers were all enjoying themselves. I loved Blackpool with its lights and piers, and as the people arrived in their charabancs they were all smiling, ready for fun.

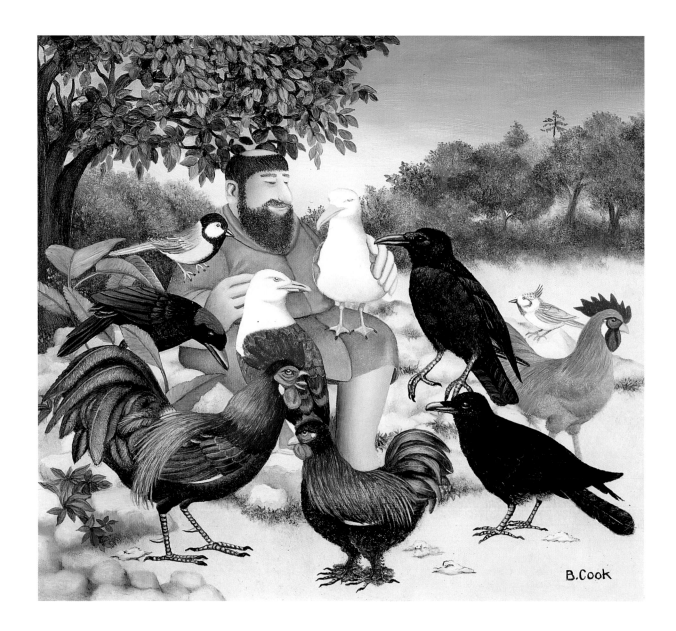

St Francis and the Birds

This picture was painted jointly by John and myself. I did the main part and he added the realistic touches, beneath the birds' tails, afterwards. Francis was chosen during a discussion about what sort of religious subject I should do, not least because I like painting birds (sometimes) and animals. I had plenty of models for the crows and seagulls up on the Downs, and the chickens were added for their lovely colours. The little one in front isn't wearing fluffy slippers – I've tried to give her feathered legs.

THE PEACEABLE KINGDOM

A friend gave us a print of the lovely Edward Hicks painting of this subject. It used to hang just outside a doorway, where I could see it every evening as I sat on the sofa, and I liked it so much that one day I decided to paint my own version. I'm very fond of warthogs and this is the one I sponsored at the London Zoo. The lion came from an old children's book of Bible stories, and since I like doing hair he got plenty. The two little cherubs are there to give it a religious tone.

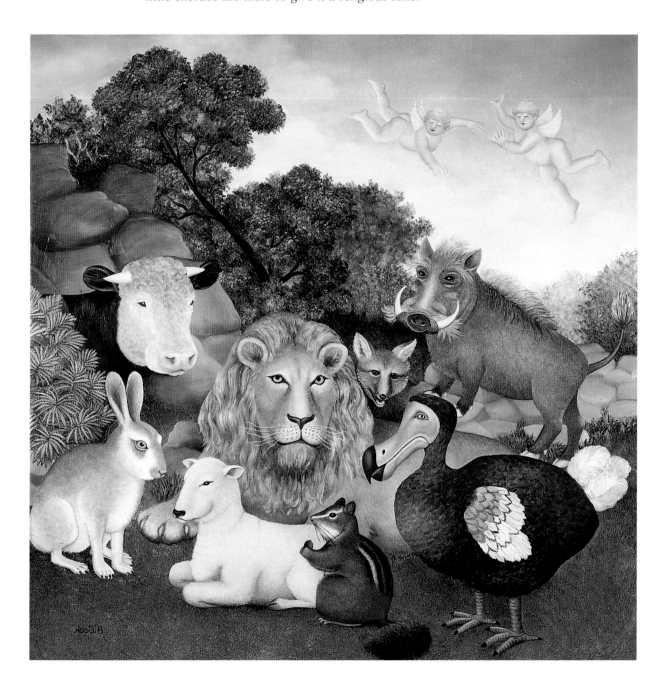

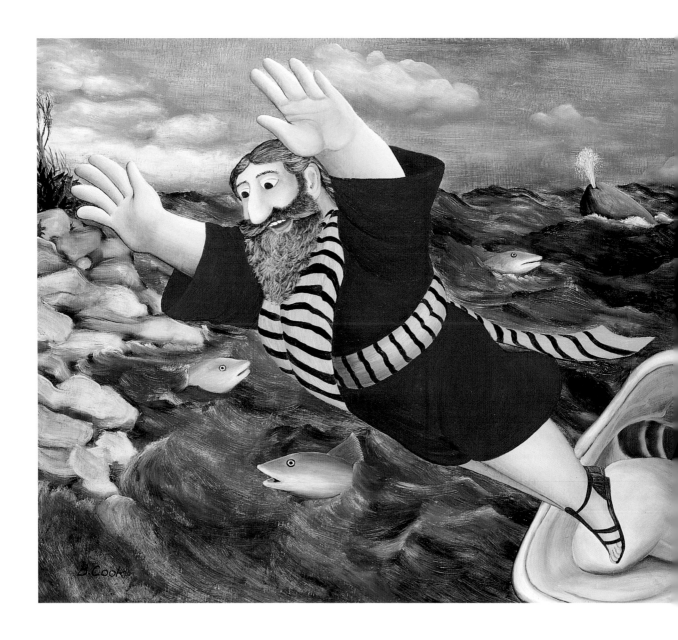

JONAH AND THE WHALE

I painted this a long time ago for an exhibition, and was very pleased to see it again recently when it appeared in the Alexander Gallery. It seemed to me to be rather good – magical, in fact, for Jonah emerges from the whale's mouth in bone-dry clothing. When painting a religious picture I use my book of children's Bible stories for tips on appropriate attire in those days. It's a Victorian book, and my only regret is that it is not twice the size, with many more stories.

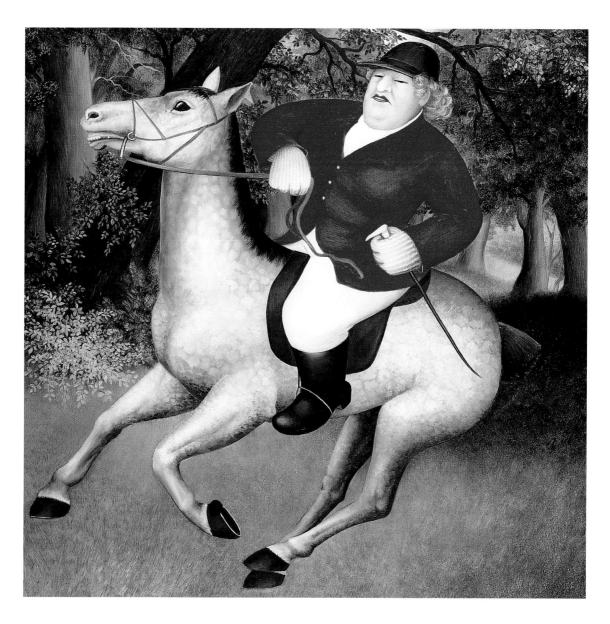

TALLY HO

Tally ho indeed! This was painted such a long time ago I can't now remember why. The rider is mounted on a royal horse which I saw in a newspaper photograph, and her outfit is very smart, right down to the string gloves. The horse has a fine row of teeth and a wild eye, possibly at having to carry this rather large and superior rider.

DOGS

I quite often paint dogs. We've had a few ourselves and they always have their portraits done. Here, gazing at himself in the mirror, we have black Bertie, a rather naughty dog who belonged to a friend. He was obsessed by balls and would catch and destroy any he could get his teeth into, no matter who was holding or playing with them. This became rather costly, and he was finally found a 'good home'. Minnie the terrier and Lottie the dachshund were ours but are now, unfortunately, only with us in their pictures. The two little Pomeranians were sitting in their basket in an antique shop, and I asked if I could take a photo. I painted them from this to give to the friend who'd been with us at the time.

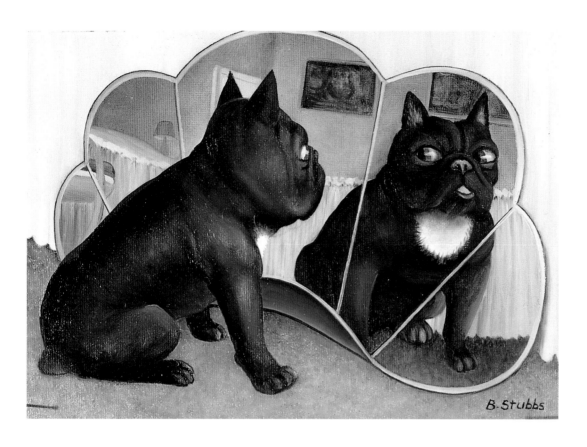

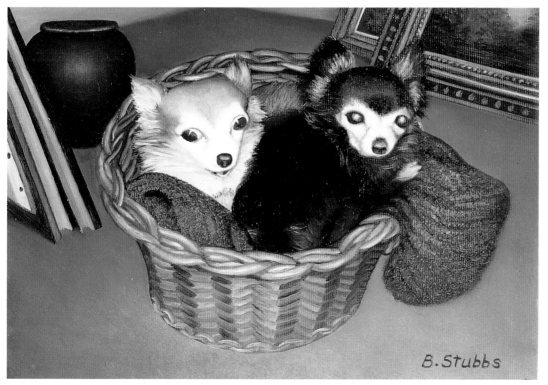

MIRO

Miro was a much-loved cat, owned by Bernard Samuels when he was in charge of the Arts Centre in Plymouth. Bernard was an enthusiastic supporter of music, literature and poetry as well as art, and he helped many people, including myself, to enter the art world. In this heady atmosphere Miro took on the role of cultural ambassador and graciously greeted visitors at the door. He considered he was entitled to only the very best in food – sole cooked in butter and chicken breasts were his favourite. In the painting he is surrounded by delicate china bowls and impatiently waits for them to be filled.

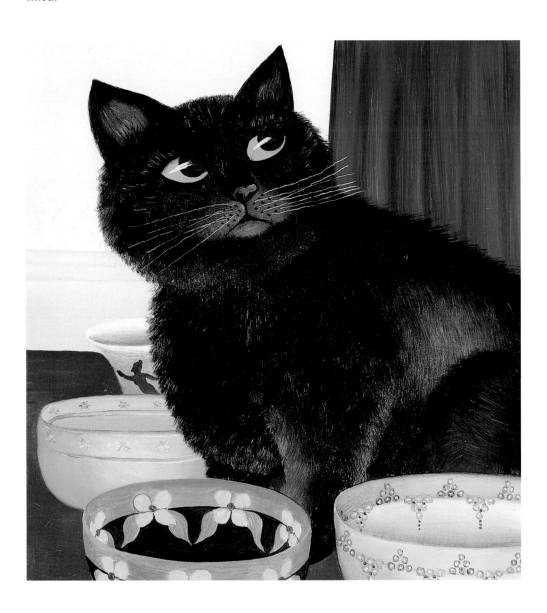

SUNFLOWER

I really don't know what
to say about this except
that I have always liked
sunflowers.

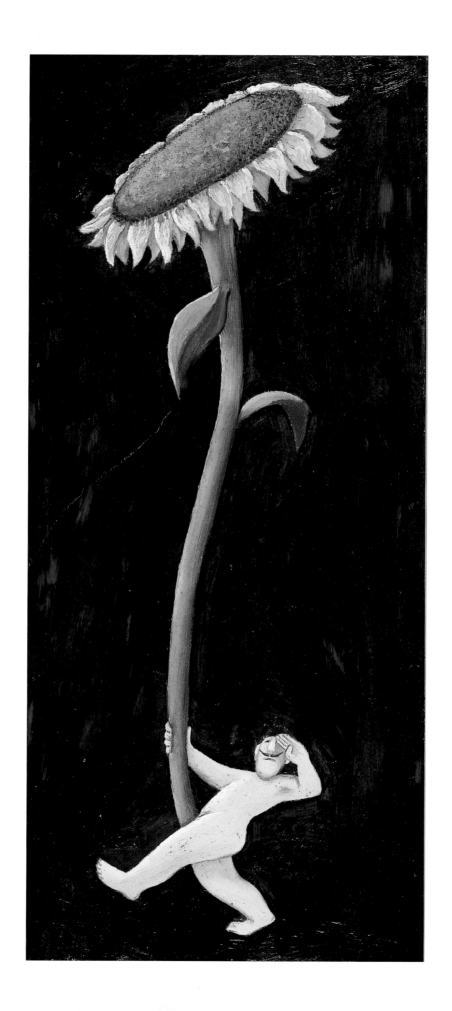

Beryl Cook's paintings are available from
Portal Gallery Ltd, London

Limited edition prints are available from
The Alexander Gallery, Bristol

Greetings cards and calendars are published by
Gallery Five Ltd, London

Original serigraphs and lithographs are published by
Flanagan Graphics Inc., Haverford, PA, USA